Art Collecting 101

Buying Art for Profit and Pleasure

10-Digit ISBN 1-59113-796-9
13-Digit ISBN 978-1-59113-796-2

Printed in the United States of America.

Booklocker.com, Inc.
2005

Art Collecting 101

Buying Art for Profit and Pleasure

Alan Klevit

Acknowledgements

Special thanks to Aurilla Fusco. The topic as a talk at Georgetown University was your idea. This book is the logical extension.

At least it was to my wife Patty. You came up with the idea while we were driving home from our Georgetown weekend. Based on the enthusiastic response to the talk, you insisted that there was a need for a handbook for erstwhile art buyers. Thanks for the idea and your endless support as a cheerleader, editor and taskmaster.

I am also deeply indebted to those special people who bring their unique visions to us and enrich our lives. Artists. Thank you all.

Contents

ABOUT THE AUTHOR .. ix

INTRODUCTION .. xi

WHO IS AN ART COLLECTOR? ... 1

WHAT IS ORIGINAL ART? ... 7

A LESSON IN PRINTMAKING ... 11

THE IMPORTANCE OF ORIGINAL PRINTS 19

THE 20TH CENTURY EXPLOSION IN PRINTMAKING 23

ORIGINAL PRINTS AS INVESTMENTS 27

CRITERIA FOR BUYING ART FOR INVESTMENT 35

HANDLING AND CARE OF ORIGINAL PRINTS 41

EPILOGUE .. 45

APPENDIX I
Lend Me A Hand .. 49

APPENDIX II
Don't Buy Art at a Yard Sale .. 53

GLOSSARY OF TERMS .. 57

SUGGESTED READING .. 61

ABOUT THE AUTHOR

A lan Klevit has been active in the art world for thirty years. He owned and operated four galleries in the Washington, D. C. and a wholesale showroom on the West Coast. He was also a private dealer and adviser for assembling corporate and personal art collections. He and his galleries specialized in original works by 20th century masters and emerging artists.

Alan has been an art consultant, artist's representative, publisher, lecturer, auctioneer, curator, and charter member of International Fine Art Appraisers. He had a radio show for two years, "Today's Art World with Alan Klevit" that aired in the Washington, D. C. Area; and hosted two television shows on the arts for six years, which were shown in the Los Angeles Area. Klevit has written for numerous papers and art magazines and currently writes a syndicated column, *The Art Beat,* which has appeared in newspapers from coast-to-coast, from THE MALIBU CHRONICLE to the PHILADELPHIA INQUIRER. Alan conducts art auctions for charities throughout the United States, and is a sought-after speaker for civic organizations and local television shows. As a result of his passion for the arts, Alan Klevit has become a nationally recognized art advocate and art maven.

You can reach him at alan@the-art-beat.com.

INTRODUCTION

I bought my first piece of original art at a Sears store in White Oak, Maryland in 1963. They had a portion of the store devoted to original art, called The Vincent Price Collection. He was quite a collector and a poignant quote by him is included later in this introduction, which clearly describes his feelings toward art. Anyway, the piece was a black and white etching by the French artist, Pierre Bonnard. I paid seventy dollars. Framed! I had no idea whom Bonnard was, nor the fact that he was represented in the Metropolitan Museum in New York, the National Gallery of Art in Washington, D. C., the Hermitage in St. Petersburg, Russia, the Guggenheim, the Museum of Modern Art…You get the idea. He is well renowned.

A few months later, my wife and I picked out two or three more pieces for less than a hundred dollars each, also from the Vincent Price Collection. I do not recall the names of the artists. My next foray into the world of art was a few years later, when I bought two black and white lithographs by Marc Chagall from a small gallery in Charlottesville, Virginia, across the street from the University of Virginia main campus. They were unframed and cost me fifty dollars apiece.

I did not buy another piece of art until I went into the art business in 1974. At last look, the Bonnard was worth over five hundred dollars, each of the Chagall's perhaps twelve hundred dollars. They are not for sale.

I have extolled the virtues of buying art for investment as well as pleasure since the late 1970s, when I became a purveyor of fine art. Initially, I gave talks in my galleries and sent newsletters to my clients. Then I expanded my activity, providing art and talking at galleries throughout the United States. In the early 1990s I led discussions on my television show and spoke on

the pros and cons of collecting art at various civic organizations and on upscale cruise ships.

It never occurred to me to write a book on the subject, until...

I was invited to give a lecture at my alma mater, Georgetown University, in June 2005, at the Alumni Weekend. Aurilla Fusco, Director of Development, Main Campus Libraries, came up with the title: *Art Collecting 101*.

When I accepted the invitation, art collecting was not the subject I had in mind. I am driven by a passion to raise the level of art appreciation and community involvement in the arts. My column, *The Art Beat,* combines Art Appreciation 101, social criticism, critiques, biographies, and my personal experiences with artists and the art world, with an occasional "how-to" for buying and collecting art. In them I advance what I consider my raison-d'etre—to be an art advocate. So I was a little disappointed and called Aurilla to ask if I could change the title of the talk. Alas, it was too late. *Art Collecting 101* was splashed all over the Georgetown University website and in mailers to alumni.

What a fortuitous turn of events! Aurilla proved to be right. The subject was exactly what people wanted to hear and talk about. I was delighted with the experience and gratified by the response.

The group consisted of collectors and would-be collectors. They had plenty of questions and wanted to share their experiences and get an assessment of those experiences.

Participants were enthusiastic, interested and had a great appreciation for art. Questions were sincere and most of them evoked spirited discussions. The dynamic of the group was outstanding. Many of the same people attended an auction I conducted that afternoon for benefit of the Lauinger Library.

The success of the lecture, combined with a few handouts I have written over the years on art collecting, blended with columns I have written and talks I have given provide the genesis for this book. And it all dovetails with a goal I set twenty-five years ago:

To provide sound advice on buying, collecting and understanding fine art, especially original works by twentieth century masters and leading contemporary artists.

Apropos to the background for this book are answers I gave to three questions posed to me when I volunteered to be an "art expert" for *AllExperts.com,* the oldest and largest free Question and Answer Service on the Internet. These are the questions and my answers:

1. What do you like about this subject? Art is the soul of society. It chronicles our past, mirrors the present and often predicts the future. It brings beauty to our world. As Vincent Price said on his deathbed: "If there is no art in heaven, I don't have to go there."

2. What do you still hope to achieve/learn in this field? To see more art, as one cannot get enough of a good thing, and to promote the arts and get more people to enjoy them.

3. Something controversial or provocative about this subject. Be careful buying expensive art on the Internet unless you are an expert. I have come across numerous supposedly original works by big name artists which were NOT as claimed. Either the seller didn't know or didn't care.

That talk at Georgetown opened my eyes to the fact that this book fills a void. Most art lovers, those who collect and those who would like to, are ill-equipped to engage in today's art market. It is too easy to be victimized. You need to know the meaning of various terms. You need to know what to buy. How much to pay. And what questions to ask.

You can benefit from an insider's view of the ins and outs of collecting art, and from someone with no vested interest. I am that person. I am your personal guide, your *art maven in a book.*

Whatever your reason for buying art, whether it is for aesthetic pleasure, decoration, investment or a combination, this book can help you. It provides vital criteria for choose art, as well as information that could prevent you from buying a fake or overpaying for a piece of art.

It can also help you understand art a little better and perhaps enjoy it a little more.

Alan Klevit

WHO IS AN ART COLLECTOR?

W henever I am a guest speaker, I begin every talk, lecture and discussion I have on the arts with the same question. I have asked it as a guest speaker at Chamber of Commerce gatherings, Rotary Club and other civic group meetings, at charity fundraisers when I am the guest auctioneer, and as the resident art expert on cruise ships. I most recently asked the question in June 2005 at Georgetown University, where I gave the previously mentioned lecture on Art Collecting.

Wherever, whenever I ask the question, I ask for a show of hands and immediately raise mine. The question is: *Who is an art collector?*

Would you raise your hand?

Most of the time mine is the only hand that is goes up. Occasionally, another one or two, but rarely more than a handful. So I ask the next question: Who here owns at least one piece of art? I don't care if it is a painting, sculpture, lithograph, etching, or a piece of photography, whatever. Just about everyone in the audience raises their hand. How about you?

Many people are art collectors who do not think they are. Most have a perception of art collectors that would never include themselves. For one thing, they think of someone with an extensive collection of art worth millions of dollars. And they see a collector as portrayed in the movies or on television as some snooty character with lots of money that chooses art for esoteric reasons at gallery openings. The men wear dark suits or navy blue blazers with ascots, and the women are bedecked with jewels.

Art dealers and gallery owners are depicted in much the same way plus speak in a condescending manner. Okay, I admit that I wore a tuxedo to more than one of my gallery openings, but just

as often I wore jeans and cowboy boots. During normal business hours I never wore a tie, although I thought I dressed smartly. And more than a few clients enjoyed dropping by for a cup of coffee or glass of wine to talk about art, as well as current events and sports.

There seems to be a perception, certainly fed by the media, that only those people who spend inordinate amounts of money buying art at international auctions and upscale Madison Avenue-type galleries are real art collectors. The fact is, those people represent one type of collector and represent a small portion of the world of collecting art. Not in dollars, but in sheer numbers. Most of the people I have sold art to over the past thirty years do not fit that mold any more than I do. They are, by and large, "regular" people who enjoy art for art's sake.

Another misconception is that fine art is out of reach of ordinary people. The truth is, fine art can be surprisingly affordable, and is well within the reach of many people who think otherwise.

If you bought a few pieces of art to decorate your office or place of work, you are a collector. If you bought a few pieces and hung them on the walls of your house, you are a collector. If you saw some pieces you liked while traveling abroad and bought them to remind you of your trip, you are a collector. It does not matter why you bought it or what you paid or where you bought it. It could have been at a gallery, a flea market, a charity art auction, an outdoor art exhibit, through a decorator, or directly from the artist. Whatever the source, the place, the price, the motivation, if you bought it, you are a collector.

I suspect that you are probably an art collector. You should raise your hand!

People buy art for various reasons, and all of them are equally valid. They buy for decoration, which is probably the number one reason. Beautify your home. Bring sophistication and

beauty to your office. Others get a great deal of aesthetic satisfaction from art. They feel good simply having it around. For them, it is nurturing and comforting. Of course, different strokes for different folks, and what nurtures one person might disturb another.

I had a client who collected works by 20th century master, the surrealist Joan Miro. She liked the playfulness, almost child-like quality of his lithographs and etchings. "Can't walk by one of my Miro's without smiling," she often told me. Yet another client, upon being introduced to Miro's art for the first time, said, "My granddaughter can do that, and she's only five!"

I was giving an "art talk" on a cruise ship in the Mediterranean, discussing the rising prices of art by 20th century masters when a familiar voice in the back of the room boomed out, "How much have the pieces I bought gone up?" There in the back of the room was my cousin Frank, grinning from ear to ear. After I stopped laughing I introduced him to the rest of the audience. "Great to see you Frank. May I tell the people what you own?" He gave me permission. I knew every piece he had since he bought them all from me. And they had all appreciated significantly. I shared that, too, and Frank beamed as the audience murmured their approval and eventually broke into applause. I'm not sure if they were applauding Frank or me. It didn't matter.

Frank and I had lunch in Sicily the next day and I asked him if he was interested in selling any of his art. "Of course not," he exclaimed. "I just enjoy knowing it's going up. It makes me feel good. And I doubt I'll ever sell it." So there you have another reason people collect art: Pride.

Still other art collectors are driven by the prestige factor. Bragging rights. I have a friend who bought a number of hand signed original graphics by Renoir, Picasso, Chagall, and Miro. There are some very rare, fairly expenses in his collection. He

loved to entertain and enjoyed taking his guests throughout his house, not unlike a docent at a museum, proudly pointing to various pieces and announcing the names of the artists. He knew very little about art and was not particularly interested in learning. He just liked to "name drop" famous artists. He would then defer to me, his personal art dealer and adviser. I would explain why each piece was so valuable and collectable. I didn't mind, because I enjoy talking about art. Besides, I often got new collectors out of the evening.

The prestige factor works well in professional offices, too. Art by recognizable names tells your clients that [1] you have taste; [2] you have class; [3] you are successful. That is why so many top law firms have outstanding art collections rather than decorating their walls with posters. That would be like wearing a ten-dollar tie with a suit by Emerengildo Zegna or Hickey Freeman. Or driving a Kia instead of a BMW or Mercedes.

Some law firms as well as large corporations have in-house art consultants. They arrange shows and look for appropriate pieces to add to their collections. I have worked with a number of them over the years. Some firms have annual exhibits at their offices, displaying their collections or introducing the works of a new artist in their collection, often with the artist present.

Finally, some people collect art for investment purposes. It has proven to be an outstanding vehicle in that arena, consistently outperforming virtually every other type of investment over the long haul. Rare coins, antique cars and similar very limited supply items have done well, too, but not at same rate of appreciation, because the demand for them is not as rigorous. Besides, enjoying the art on your walls, then giving it to your children--keeping it in the family--is another way of building and handing down estates to heirs.

Still others build collections over the years, get a lifetime of fulfillment from each find they add, and the joy of owning the art,

and then donating it to their favorite charities. They get the pleasure from the art and, if it has appreciated significantly over the years, not an unusual occurrence, they get a tax break on their donation. I am neither a tax attorney nor an accountant so if the idea appeals to you, get professional advice.

There are also people who collect art for all of the above reasons.

Because of the diversity of reasons for collecting art, there are different criteria that should be applied in determining the value of a piece of art. For investment, obviously buying at the lowest possible price is desirable. For the other reasons, since beauty in the eyes of the beholder, the value of a work of art can be personal.

Later on I will spell out specific guidelines for buying art. For now, there are basic rules to abide by:

- Buy what you like. You, not your decorator or financial adviser.
- Be careful buying on line, unless you are an expert [I will share some horror stories later].
- Be careful what you buy on Late Night TV unless you are an expert [same as above].
- Be careful what you buy through the classifieds, unless you are an expert.
- Be careful what you buy at a yard sale, unless you are an expert.
- Notice a pattern? If it sounds too good to be true, it probably is!
- When buying for investment, traits you should consider are history, liquidity and visibility.
- Worth repeating: Buy what you like.

WHAT IS ORIGINAL ART?

O nce I have determined that most people who attend my talks are art collectors, the second question I ask is a natural: *What is original art?*

Unlike the first question, to which no one raised their hand, this one evokes responses from every corner of the room. People don't bother raising their hands. The question is barely off my lips and people invariably shout out, "paintings," "sculpture," "drawings," "watercolors," and an occasional "collage." Of course, they are all correct. Not an unoriginal in the bunch. Every one of those mediums has been used by an array of artists over the years to express their creativity. And every one of those mediums is created directly by the artists, onto canvas, paper, wood, molded from clay, hacked out from marble, and so forth. Paints are made with oil, acrylic, water, herbs and minerals, and, yes, even elephant dung, which caused so much controversy a few years ago at an exhibit in Brooklyn, New York.

But what about the sculptures by the 20th century British master Henry Moore that are planted in the middle of the pond in Central Park, New York? He didn't do them. At least, he didn't do them directly. Not "personally." He didn't lay a hand on them until they were done and he affectionately ran his hand over the finished product, although they would have been just as original if they were produced posthumously.

Those sculptures, as well as the gigantic one Moore created that looms at the entrance of the East Wing of the National Gallery in Washington, D. C. *are* original works of art by Moore. They are among Moore's most admired and popular works. What makes them original is their creative intent. Sir Henry had the vision, the idea. Based on that vision, he molded a clay model of what he wanted and that model, known as a maquette, was then blown to full scale according to his specifications. A mold was

made and the final works cast in bronze and deposited in Central Park and on the Mall. One cannot question that those gigantic monoliths were the creative inspirations of Henry Moore, and they are his original works of art. Not unlike buildings designed by architects. The artists are not the bricklayers and painters, carpenters, and foundry workers. This is not intended to impugn the craftsmanship of artisans whose talents are necessary and considerable. But they collectively produced Moore's creative intentions.

By the way, it is customary to use the maquette to make a mold and create an edition of six to nine examples in bronze, each piece hand engraved by Henry Moore. They too are originals.

What about prints? Are they--can they be original? Or are they mere reproductions? The very term *print* has been bandied about and used to describe various techniques and products, as well as, in certain cases, obfuscate and deceive. Some history of printmaking is in order.

Printmaking was invented in the 15th century. The inventor, Guttenberg, conceived it as a reproductive process, to copy existing images, usually important texts and other documents. Otherwise, reproduction meant copying one at a time with ink and quill, an arduous process to say the least. That notion is still present in various forms, including four-color separations [offset lithography], xerography, laser printing, ink jet, iris prints [a.k.a. giclees]. They are all methods used to reproduce something that already exists. They are not originals, an unfortunate legacy to the uninitiated. They are copies.

Making original works of art in various print mediums came later. I want you to reconsider artistic intent. Original printmaking is about creating art using different techniques heretofore used. And great artists that worked in more than one

medium dominate the history of printmaking. Masters that painted as well as made prints.

Virtually all the great masters made and excelled in printmaking: Durer. Rembrandt. Goya. Matisse. Picasso. Chagall. Miro. Johns. Warhol. They are just a cross-section. By the way, Rembrandt considered his prints to be as original and important as his paintings. He considered his 334 etchings to be his greatest expressions of creativity, and painted portraits to make a living.

So the question is: What makes original prints original? After all, since prints are generally created in multiples, how can they be original?

First of all, we must go back to artistic or creative intent. What is the purpose for the technique, whatever the medium used. If an artist envisions an image and decides to create it as an etching or a lithograph that requires multiple plates or stones, the stacks of plates or stones are not the originals. The same is true for a pile of stencils that might have been used to create a serigraph. A few paragraphs ago, I referred to reproductions as copies. Original prints are not copies. There is no previous manifestation of the creative idea conceived by the artist.

The original art is the end product, the result of the single combined image of all the plates, stones or stencils. And that is true whether the end product is one example, or a series of examples, each of which is identical to the others in the series, or edition, as it is more commonly known.

That brings us to the question of unique versus original. They are different terms with different meanings. Unique means one-of-a-kind. That is not synonymous with nor implies original. There can be multiple originals, such as all the examples in a series or edition of identical examples, also known as prints. This should become clear when we describe the various techniques commonly used to create original prints.

But you should recognize the danger of an art salesperson referring to something as a print. Is it a copy or is it an original? You need to ask what he means.

A LESSON IN PRINTMAKING

T here are dozens of printmaking techniques used by artists to create original prints.

Some are variations on a theme. For example, lithography began with specially treated limestone blocks, whereas today Mylar and metal plates are equally in vogue. I prefer the nuances that can be achieved the old-fashioned way, but that is personal preference. Different techniques in etching have also been implemented. The use of mezzotint, dry point, aquatint, and carborundum, to name a few, bring different textures and tones to the final images, reflecting the creative spirit and individuality of artists. There are artists who use several of the techniques on a single image to achieve a different print than anyone else created. Picasso and a few others blended lithography and etching. The potential for creative expression through printmaking is boundless. And there are new mediums created every day, utilizing photography and computers.

I have restricted this survey of printmaking to the most prevalent and historically significant mediums.

- Lithography. Based on the concept that oil and water don't mix, the artist draws directly on specially treated stones with an oily crayon and ink is transferred to paper via a high-powered litho press. Up to twenty stones can be used to produce a colorful lithograph, each stone utilized to create a portion of the finished product, and it is only the combination of all of them that results in the image the artist had in mind.

- Etching. Named from Dutch [etsen] or German [atsen], meaning "to eat," the artist draws onto a plate, which has been specially treated [protected], scratching through the protected area. The plate is dipped in acid, which eats through

to the plate, where it has been exposed. The plate is then inked and wiped, the ink filling the drawn lines, and the image is pressed onto paper. Numerous plates, treated in various ways, are used to produce colored etchings and variations on the technique produce textures, aquatints and the like.

- Woodblock/Linocut. A reversal of the etching process. The artist carves [draws] directly onto a wood or linoleum block, gouging out the image. The area carved out is not where the ink ends up; the rest of the block is. Like the other techniques, multiple blocks are required to produce complex, colorful images.

- Serigraphy. A 20th century technique in which the artist makes stencils of screens of silk mesh, and ink is pressed through open areas onto the paper. Fifty or more screens can be used to produce a single image. Serigraphy became popular in the 1960s because of its ability to produce bright areas of color.

There are several printmaking methods conspicuously missing from the above group. Yet, because of their prevalence in the world of art and the penchant by artists, publishers and dealers to offer them as original art, I feel required to talk about them.

Offset lithograph and giclee [iris print] have been excluded because, despite the claims to the contrary by their purveyors, they do not fall under the definition of original printmaking. They produce copies.

Again, offset lithography is not a printmaking technique. It does not produce multiple original works of art. It reproduces an

original work of art that already exists, utilizing offset printing and what is know as four-color separations.

Much to my surprise and chagrin, early on in my art gallery days, I read about limited edition original prints offered by a plethora of publishers. Produced in editions of seven hundred to a few thousand, these prints are numbered and hand-signed by the artists. In some cases, the original paintings were also available. Publishers and galleries selected to be part of the program to distribute [sell] the prints extolled their investment potential and spoke of secondary markets for sold-out editions. If you bought any of them in the 1970's, good luck selling them for profit.

Also excluded from the list of original printmaking techniques is today's hot commodity, giclee. As defined by Wikipedia, a free online encyclopedia:

Giclée (French for "spray") is the use of the ink-jet process for making Fine-Art prints (first done in the early 1990s). Originally the term applied to "Iris" prints created on the Scitex Corp. "Iris Model Four" color drum piezo-head inkjet proofer. Proofers are specialized commercial printing machines designed to proof or show what the final multi-color process printing will look like before mass production begins. The term "giclée" is frequently used to describe any high-resolution, large-format ink-jet printer output with fade-resistant dye or pigment-based inks. It is common for these printers to use between seven and twelve color inks. Though originally intended for proofing, many artists and photographers use ink-jet printers as an alternative to lithography for limited editions or reproductions.

The process is in vogue because [1] it is a relatively inexpensive method; [2] artists can adjust/improve the colors,

even change them completely from their original work of art; and [3] the colors can be very vibrant. The last line from the Wikipedia definition bears repeating: "Though originally intended for proofing, many artists and photographers use ink-jet printers as an alternative to lithography for limited editions or reproductions."

Fine. Just don't sell them as originals.

I am appalled and frightened when I see advertisements on websites for "museum quality" and "fine art giclee printing," tossing about such terms with reckless abandon.

Let's get back to original printmaking. There are a number of concepts and terms that you should be familiar with if you collect fine art.

The practice of hand-signing original prints is a 20th century phenomenon, as the recognition of prints as collectible originals became obvious. James Whistler signed some of his pieces in the late 19th century and some artists had previously signed their names in the plate or stone, although the practice was inconsistent. Rembrandt, for example left as many of his images unsigned, while putting an abbreviation of his name on others and his name on still others.

It took the evolution of art publishers and dealers and an expanding art market for hand signing as well as numbering prints to come into vogue. Pencil, sometimes crayon, are preferred, because they are the most difficult to reproduce through a copy process.

Some artists print more than one edition. Usually, but not always, one edition is signed, the other unsigned or only signed in the plate. Generally, although there is no hard and fast rule, the margins are wider on the signed pieces, and the paper size is spelled out in a catalog raisonee, if there is one for the artist.

"Signed in the plate" means the artist signs his name on the plate or stone before the pieces are pulled, and that signature is then reflected in each example of the edition. Unsigned editions tend to be larger than the signed ones.

Numbering, as mentioned above, is a twentieth century phenomenon. There are several reasons for numbering. One is to provide instant information to the prospective buyer as to how many pieces there are in the edition. Of course, that could also be achieved by simply writing down edition size [for example: "ed. 200"], and there are artists who believe that is more accurate, since one can never be sure that each pull of an example in edition is in the same position each time. Jack Perlmutter, an esteemed printmaker who headed up the print department at the Corcoran Gallery in Washington, D. C., and whose works are in dozens of major museums, is one such artist. He created two editions for me in the 1970s and was adamant about indicating edition size rather than assigning specific numbers to the pieces.

Perlmutter explained his rationale this way: "When I use a handful of stones to create an image, each stone is inked separately and the color transferred to paper, I can't be a hundred percent sure that the first print to have the green put on the paper was the first to have the red and orange applied. It could have been number one for one color application, number twelve for the next, and number sixty for the next. The only thing I know for sure is how many examples I print in the edition."

The primary reason for numbering is to help with sales. Contrary to public opinion, the number of an example does not matter. Number four out of a hundred is no more valuable than number thirty-seven of a hundred. Auction records have clearly reflected that. Still, people who sell art will use the number as a tool, a selling aid.

There are also letters that appear on prints: AP, EA and PA the most prevalent. You should understand what these are and their implications.

All three stand for "artist proof." English speaking printers and ateliers use AP. In France, ateliers such as Mourlot use EA, the abbreviation for "epreuve d'artist," also artist proof. And in Spain, PA is the abbreviation for "Prova d'artista." In other words, however abbreviated, they all mean the same.

But what is an artist proof?

It is not, contrary to popular opinion, from the artist's private collection, and therefore worth more money, as some dealers would have you believe. Of course, that is probably because what they have to sell is an artist proof. And they are not, contrary to somewhat less popular opinion, worth less money because they are "proofs" created to check out the image before pulling the "better pieces" that will be numbered. That was sometimes the case but has long ceased being the practice. When the exact image the artist wants is printed and the artist approves it, that print is marked "BAT," which stands for "bon a tirer." "Bon a tirer" is French for "good to pull."

In reality, artist proofs are a way to increase the size of an edition, generally up to ten percent. Sort of a mini-edition added on. Thus, a numbered edition of 100 could have an additional 10 artist proofs. They are the same quality and value as the numbered examples of the edition. Some artists number their AP's, like "AP 3/10." Only the most greedy artists and publishers would have up to twenty percent artist proofs.

There can be a handful of prints with a different label, "HC." That stands for "hors commerce," which is French for "not for trade." They are often special payments to artists and others who made the edition possible. There are generally only a handful of

HC's. Some galleries sell HC prints for more money than numbered pieces, because they "came from the artist's private collection." Although that might be true, it is also true that the quality of the example and the artist's signature are the same.

THE IMPORTANCE OF ORIGINAL PRINTS

N ow that we have established that original prints are, in fact, as original as other methods of artistic expression, such as paintings and sculptures, we must clarify another point. There is a widely held misconception that prints, albeit original, are second-class citizens in the world of original art. It is not unusual to hear them referred to as "only prints," even by dealers, as though they are inferior to other art mediums. Printmakers are often not held in the same esteem as painters and sculptors.

That is a misconception. Prints are important to artists and not just those who are exclusively printmakers. As a matter of record, prints are especially dear and most important to artists who excel in other mediums. Great artists who made both paintings and prints dominate the history of printmaking. Or sculpture and prints. Or all three. Most of the great masters excelled in printmaking and embellished on the techniques used in the various mediums. A few notables are worthy of mention.

More than anyone else, it was Albrecht Durer who established the print as a major art form. Durer created the German Renaissance almost single-handedly, chiefly by means of his prints, which spread his forms and ideas throughout Northern Europe. Many art historians consider him as great a Renaissance master as Leonardo, Raphael and Michelangelo. The two graphic media that he used the most were woodcut and engraving, although he also dabbled in etching in the early 1500s. His works captured an intimacy and vitality that few other Renaissance artists could match. His prints, essentially drawing on blocks of wood or metal plates, are drawings, and nothing can match drawing for intimacy.

Rembrandt considered his prints to be as original and important as his paintings, although he borrowed from other masters, including Durer and Leonardo de Vinci. His etchings

evoked meditative and spiritual feelings, through his technique of *chiaroscuro,* the use of light and shadow. As I said, he considered his etchings to be his greatest expressions of creativity and painted portraits to make a living. Frequently, he would have his students "pull" an example, sometimes referred to as a proof [ink the plate and transfer the image to paper], and then decide to rework the print. Not unlike me reviewing this article and editing it, refining it. That is why a number of his prints have more than one state. Each time he reworked the plate to create a variation on a theme, that is a separate state. As looking at his work sparked still further creativity, he would further work and rework the plate, sometimes to the point that a number of his plates eventually wore through or cracked.

Another century produced Goya, indebted to both Durer and Rembrandt. He incorporated the lines of Durer with the light and shadows of Rembrandt. Then, by adding the technique of aquatint to his etchings, he achieved tones and effects that had been beyond the reach of printmakers before the 18th century. Those tones, achieved by working the plate at different times, resemble the flat tints of an ink or wash drawing or watercolor, hence the name "aquatint" from the Italian or French. A great painter, he, too, excelled in printmaking and is equally known and renowned for his etchings as his paintings.

And so it went into the 20th century. The great artists used printmaking to explore the farthest regions of their imagination, even more than many had ever done in painting or sculpture.

Throughout the ages, just as great painters had different techniques of prepping canvas, applying brush strokes and layering and glazing paint to create different textures and shading, great printmakers had their own techniques. We have already described the working and reworking of his plates by Rembrandt and the infusion of aquatint by Goya.

In the 1960s, at the age of 69, Joan Miro set up a print studio because he felt his prints were more and more important and central to his artistic message. During the last twenty years of his life, Miro had nearly twenty exhibitions exclusively of his prints, which combined calligraphy, brightly colored planes and solid backgrounds. Miro was equally facile in both lithography and etching. He built upon the aquatint process advanced by Goya and was among the first masters to incorporate carborundum into the etching process, working with the great Mourlot Atelier. This technique introduced a different kind of texture and indentation to the final image, and allowed him to draw with the wider, sweeping brush strokes that characterize many of his late works.

Picasso, as well as other artists, utilized dry point and aquatint in conjunction with other etching techniques. The quintessential printmaker, Picasso etched images on ceramic sculptures, combined lithography and etching, and was still experimenting with printmaking ideas into his late eighties. Like Rembrandt and Goya, he easily moved into printmaking where he made some of the greatest images, not only of his career, but also in the entire history of art. His lithographs are brilliant displays of line drawing, while his etchings, incorporating techniques such as dry point and aquatint, created breathtakingly painterly effects.

Picasso further enhanced his contribution to 20th century printmaking by playing a major role in the development of the linoleum cut [*linocut* for short]. Rather than relying on delicate lines, linocut requires broad sweeping gouges in linoleum, and the process lent itself to reflecting Picasso's powerful imagery.

The great artists are continually experimenting. For example, the Mexican master Rufino Tamayo used a blowtorch to sear the edges and affect the texture of the hand made paper on which he printed his mixed media prints. That's control! And Andy Warhol created images by combining serigraphy and photography.

Photography is well on its way to be considered the printmaking technique of the twenty-first century.

This skims the surface of the creative spirit that has inundated printmaking. In short, there is just as much creativity in the process as the image.

THE 20TH CENTURY EXPLOSION IN PRINTMAKING

T here is an historical correlation between the 20th century explosion in printmaking and the emergence of capitalism and the middle class in America.

For hundreds of years, only a handful of people could buy art, usually royalty and the upper classes. I recently watched a DVD of the 1960s movie *The Agony and the Ecstasy,* based on Irving Stone's novel of the same name. In one scene, Michelangelo complains to Raphael about how he is being abused by Pope Julius. Raphael reminds Michelangelo that artists do not own themselves. They get to create at the whim of the wealthy that pay them. And Pope Julius was a great supporter of artists, nearly as important as the Medici Family, the noble Italian family that produced three popes and two Queens of France. Another outstanding patron of the arts was Lorenzo [The Magnificent], whose clients included Michelangelo. And that was in the 1400s and 1500s.

Things didn't change for hundreds of years. For example, how many portrait commissions did Rembrandt get from working class people? None. For art not for pay, he did etchings of them. To him, etching--drawing into a plate--was a form of drawing. And drawing, as numerous artists have told me, is the most immediate and intimate form of visual expression. The Israeli master, Agam, confided to me to collect his drawings. "They are the closest things to my soul," he would whisper. Back to Rembrandt: There was no market for his etchings. The rich certainly didn't want them. In short, there was minimal demand and supply of art. He might pull one or two examples of an image for his personal collection.

The advent of the middle class created people who wanted to own the fine things in life. They couldn't afford the unique art works of masters, but printmaking, the creation of multiple originals, made fine art available, accessible, and affordable to the most rapidly growing segment of the population. It spread like wildfire and became an international phenomenon. The notion of fine art being surprisingly affordable was in full force.

But it would be simplistic to explain the explosion in printmaking in terms of chasing the dollar. There was that aspect, but by the 20th century, printmaking had become as important for creative expression as painting and sculpture. Whether an underlying cause was the immediacy of the final product is speculative, but artists turned to printmaking in droves. Then, of course, as the world of printmaking gained in acceptance, accessibility for artists as well as collectors, publishers and distributors enhanced marketability. Artists viewed this as an opportunity to make a living in the art world, not reliant on one or a handful of patrons.

Helping the printmaking advancement was the use of lithography by the French artist Jules Cheret. Able to work life size and produce prints in glorious colors, Cheret caused a color revolution and produced a significant lithograph collection. His prints advertising such places as Moulin Rouge adorned the kiosks of Paris. Lithography was the enabler for the art of La Belle Époque and such artists as Alphonse Mucha and Toulouse Lautrec. The posters of La Belle Époque artists are much in demand a hundred plus years later.

The 20th century masters viewed printmaking as a new vehicle for creative expression and pursued the various mediums for that reason. The career of Pablo Picasso, arguably the premier artist of the 20th century, convincingly illustrates the point.

Picasso started, left behind, and started again, virtually every school of visual expression of the century. When he was nine or

ten years old, he told his mother that, when he died, his oeuvre would contain all the art that ever was and would be. Arrogant or visionary? There are those who think he succeeded in accomplishing his boast. Whether he did or not is moot. What is not is his unflagging creativity for eighty years.

A look at his career and how printmaking fits into it is worth examining:

- The early numbers: Picasso produced thirty-seven prints through 1919. I'm counting that as span of about twenty years, leaving out his teens.

- From 1920-1929, the next decade, he made an additional sixty prints, more than a sixty percent increase over the previous twenty years.

- In the 1930s he upped his production to two hundred twenty-eight prints. That is more than double the previous thirty years.

- In the decade of the 1940s, he increased his output to two hundred eighty-nine prints; and he created another three hundred thirty-two in the 1950s. In short, he elevated his production every decade for sixty years. His total production was nine hundred forty-six original prints, all catalogued, during that time period. That is more than most artists produce in a lifetime.

- But that was dwarfed by what followed. In the 1960s, in his eighties, Picasso produced a staggering one thousand three hundred sixty-five prints. More than he produced previously.

Clearly, printmaking became the major vehicle for his ideas and artistic expression. As a matter of fact, from 1930 on--the second half of his lengthy--aside from his epic anti-war documentary painting, *Guernica,* his masterpieces were prints and ceramics—but predominately prints.

Other artists emulated Picasso. Masters such as Joan Miro and Marc Chagall concentrated on printmaking in the latter part of their careers, producing some of their most sought after and beautiful works. Later 20th century masters like Warhol and Johns utilized printmaking to an extensive degree, as well.

As art collectors recognized the creativity involved in printmaking from both artistic and technical standpoints, the value of prints was enhanced. A separate section is devoted to the investment aspect of prints. We will end this section with yet another story about the redoubtable Picasso, who always knew that his original prints would have investment value, and early on took steps to protect collectors of his prints.

As I mentioned earlier, hand-signing prints became prevalent in the 20th century. Picasso was one of the first artists to produce two editions of his prints. Pulled from the same stones or plates, the quality of the pieces was identical. However, he might, for example, decide to have an edition of 50 pieces that he would hand sign and 500 that would remain unsigned. To prevent forgeries, Picasso would print the fifty pieces he intended to sign on different paper than the five hundred pieces he was not going to sign. He also printed them with wider margins. The exact dimensions, including margins, are spelled out in the Catalog Raisonee of his works, as are the kinds of paper he used. Thus, a signed piece on the "wrong" paper with narrow margins is easily identifiable as a forgery.

Miro and others adopted the same practice, but once again, it was Picasso who led the way.

ORIGINAL PRINTS AS INVESTMENTS

S ome things bear repeating. Prior to the20[th] century, unique works dominated the original art market. Paintings and sculptures were the sought-after masterpieces. Until the late 19th century and the advent of color lithography, utilizing multiple stones, the prints that were available were black and white, often studies, in a sense the drawings and sketches of their time. One more thing: art collectors did not recognize their value, either aesthetically or financially.

To recapitulate, the collectors were the very wealthy, often the patrons of the arts. In feudal societies only the upper strata had the means to buy original works or commission artists to create art for them, such as portraits of their family. Between those patrons and the Church, which spawned art with religious themes, there was no support for the masters who were creating prints "on the side," so to speak.

And we know that the recognition of the efficacy of original prints by artists coincided with the growth of a middle class in America, spawning a group of people willing and able to collect art, at least at a secondary level. In a way, just as the Industrial Revolution was spawned by technology and a growing middle class that were able to acquire the fruits of their labor, so to was the Print Revolution in Art. Not long after more and more people could own an automobile, more and more people could own affordable original art—prints.

As the middle class grew in size while becoming more affluent, to accommodate that growing demand, artists produced more images and larger editions. A whole new generation of printmakers joined the group of master painters-turned-printmakers, exercising their creative spirit, spurred on by the somewhat novel notion of making a living as an artist, never easy for lesser known artists.

The print market gave artists an avenue to expose their art to more and more people, which also fueled the demand for their unique works as well. Greater visibility through an ever-increasing exposure and increasing number of collectors resulted in greater demand for paintings. As a result, the print market has had a positive effect on the value of paintings. And, as we will see later, increases in the value of paintings increase the value of prints by the same artist. Around we go!

The first and foremost question for many people is whether the value of prints is diminished by the fact that they are multiple originals and that editions are larger than they were in the past. Put differently, they ask: "Since prints are multiples, are they not as good an investment as a unique work of art?"

The answer is a resounding "No!"

Tracking auction records for decades reveals that prices for prints by the masters move at least in concert with their paintings. At least! On an individual basis, some prints have done better.

Among the reasons behind that: [1] only a handful of a particular image might come up for sale in a decade. And, [2] with an ever-growing middle class exposed to and able to afford original prints, the demand far outstrips supply and the growth of demand far exceeds the growth in the supply of prints. And keep in mind that [3] the deaths of 20th century masters shut down the future supply, while more and more people are seeking out their works that they can afford.

There are other catalysts to the price appreciation of prints. Although the number of millionaires is considerably higher than, say, fifty years ago, and more people are able to acquire million dollar paintings, when the price gets past five or ten million dollars for a painting, a lot of people are eliminated from the bidding. Even if they could afford one piece, they might prefer a

wide range of works by several artists for the same amount as one painting.

That all sounds plausible. So how have prints done in the marketplace?

One example is the 1904 print, *The Frugal Repast,* by Picasso. There are several reasons it graces the cover of this book. First of all, I love it. All told, I have stood in front of it for several hours the few times I have seen it. And I periodically open a book that I own of Picasso masterpieces, to renew my love affair with it. It touches my soul like only a handful of other works in the annals of art. Another is Michelangelo's masterpiece, *Pieta.* I stood in line for a few hours for a one-minute look at the 1964 World's Fair in New York then got back in line. I had the opportunity to become immersed in it up close in St. Peter's Basilica thirty years later.

The Frugal Repast originally sold for about twenty-five dollars. They do not come up very often at auction, but one did a few years ago and fetched an astounding $275,000.00. That equates to an eleven thousand percent increase over less than a hundred years. And that equates to a one hundred twenty percent increase each and every year. True, that is not typical. Still, to grow at that rate for a century is impressive.

We can get a better idea of how prints have made out in the marketplace by looking at broader averages covering a shorter time span.

Since I was an active buyer and seller of prints by Picasso, Chagall and Miro for the past thirty years, my familiarity with their markets simplified my research. That research reveals the solid investments the works of these masters have been. All three have enjoyed remarkable appreciation as new collectors move into the marketplace and snap up the dwindling supply.

Since the late 1970s, on average, the prints of Chagall and Miro have increased six times. That is between twenty and

twenty-five percent a year--every year--for nearly thirty years. Certain images and techniques have done better than others. Miro's etchings, especially those with carborundum, Chagall's colorful lithographs and his more whimsical pieces have outperformed other mediums and styles. But they have all performed well.

During the same time period, prints by Picasso, have increased more than eight times, virtually across the board. That translates into an average yearly gain of well over thirty percent-- each and every year.

There is no sign that things are letting up. On the contrary, they are heating up, for the following reasons. As recently as May 2005, Christie's London Auction of Contemporary Art set a new record. Meanwhile, art prices in general continue to rise: for the twelve months ending June 2005, auction prices were up 15.8 percent in euros, which, at the conversion rate at that time, was 18.1 percent in dollars. And Chagall has doubled since 2001, increasing an impressive 48 percent from 2003 to 2004. Ditto for Miro and Picasso. And Christie's and Sotheby's Impressionist and Modern Art Sales held in London in June 2005 produced six new records.

It is not hard to understand why people buy art and pass it down in the family from generation to generation. And there are several underlying reasons for the success:

• World demand for the works of these artists keeps increasing with the growing population of people who can afford prints, the bulk of which sell between $10,000.00 and $75,000. Contrast that with paintings by the same and lesser-known artists, which sell in the millions of dollars. A dozen or so paintings just by American artists have exceeded ten million dollars and a few have exceeded twenty million. Picasso has exceeded one hundred million dollars--for one painting!

• At the same time, many collectors are inclined to hold rather than liquidate their art collection. They are either in it for the long haul or they intend to pass the art down; and others simply buy what they enjoy and hang it on their walls, cognizant of the consistent growth in value but more interested in the pleasure they derive from the art. No doubt the steady climb in value adds to their enjoyment.

• The result of the above trends is increasing demand and dwindling supply worldwide. It is simple economic theory that the Law of Supply and Demand ultimately determines price. More demand and less supply equal higher prices.

Perhaps it is familiarity or marketing, but prints by artists that flourished in the 20th century have performed better in the marketplace than old masters. The works of Durer, Rembrandt, Goya, and others have enjoyed fifteen to twenty percent annual price increases during the same time period I studied. Obviously, supply is very limited and certainly not growing, which indicates a somewhat less vigorous demand for their art. Many contemporary names have done well, too. Warhol. Johns. Lichtenstein. Hockney. Noland. Gilliam. Nevelson. Bearden. Lawrence. There are many others, but that particular list, with the exception of David Hockney, consists entirely of Americans. And Hockney lives in Malibu, California. I won't speculate what, if any, significance that holds.

What about the works by emerging artists? Can they be good investments? And how about the most popular artists of the time?

Of course they can be good investments. Going back to the beginning, Durer was The Man in his time. In recent times, Warhol was popular in his lifetime. In between, so were Matisse and Picasso and Chagall and Miro. Popular artists throughout art

history have exhibited staying power. However, each was recognized early in his career as an innovator, a leader, and a master.

Others might surprise. There are late bloomers, artists whose talent is not always recognized, sometimes not in their lifetimes. But they are rare. The chances of an unknown artist's works becoming valuable are extremely slim. I often tell people it could happen. You could also dig for oil in your back yard. Strike it and you are rich! And the odds are about the same. You probably have better odds playing the lottery.

Interestingly, during that record-breaking auction conducted by Christie's, works by Hopper, de Kooning and Rothko, all created in the early to mid-sixties, brought the highest prices. Next came Warhol. And there were eleven successive no sales by the "new generation," that is, artists who succeeded them.

Many if not most big names of the day fall out of favor in all of the arts. Musicians. Singers. Authors. Artists. Only a handful of pop singers before rock and roll maintained their popularity after its explosion. Among the men, perhaps only Bing Crosby, Frank Sinatra and Nat King Cole survived. And early rock n rollers have pretty much fallen by the wayside. How many stars from the 50s and 60s still have big careers?

Who were the big fiction writers of the 1960s? The 70s? The 80s? Stephen King leads a contingent of a handful of names. Mostly, the stars of today are not the stars of two decades ago.

I recall an interview with Truman Capote, whose career was marked by some notable works [*Breakfast at Tiffany's, In Cold Blood*] and whose short stories are among my favorites. Even his arch rival, Norman Mailer, described Capote as a brilliant writer, who chose the right words to make perfect sentences; constructed the sentences to make brilliant paragraphs; and put together the paragraphs into sharp, terse, exquisite stories. Yet Capote languished by the likes of Mailer when it came to book sales.

During that interview, when asked if Mailer, since he sold better than Capote, was a better writer, Truman replied rather tersely that in fifty years people would still be reading Capote and nobody would know who Mailer was.

Right or wrong, Capote understood the nature of art and the popularity of artists. Read whom you enjoy. Listen to your favorite music and performers. Buy and hang on your walls the art that gives you the most pleasure.

But if you buy art for investment as well as aesthetic reasons, stick to the Masters. Having said that, I cannot emphasize the affordability factor enough. You can begin with a modest collection and build it one piece at a time, similar to the notion promoted by mutual funds, that is, invest so much a month or a quarter or a year. Their brochures and websites constantly show how much $100 a month would be worth in thirty years, based at a modest annual return. They point out how an investor who is steadfast can become a millionaire. The same concept applies to collecting art for investment.

A friend of mine read my column, *Lend Me A Hand,* which is reprinted as an appendix in the back of this book. She told me it stopped her in her tracks from buying a reproduction for a thousand dollars. It was a signed and numbered offset lithograph. That's fine. I am glad I could help. But what she doesn't know is how affordable fine art can be. Like those mutual funds, she could decide on an entry level and get started and build. And enjoy everything she collects.

CRITERIA FOR BUYING ART FOR INVESTMENT

I f I have whet your appetite to collect fine art, and one of your reasons for collecting is for investment potential, there are some guidelines I would recommend that you follow.

For the most part, the criteria for buying art for investment are not all that different from a lot of other investment choices. Of course, even within the same investment group, some investments are more speculative than others. That holds true for real estate, stocks & bonds and fine art. To minimize your risk, I suggest you apply the following criteria:

- Track record. History counts. Confine your investment dollars to artists whose works have appreciated over the years. You might miss a "new" shining star here and there, but those who have done well are your safest bet. I will talk about those shining stars later. This is akin the famous real estate admonition: "location, location, location."

- Liquidity. The broader the market, the better. Need to liquidate? Nationally known artists beat regional ones. International names trump national ones. As in stocks and bonds, you want to be able to liquidate when you want. The bigger the market for who you are selling, the greater your chances for success in that regard. That may not hold true in real estate, but it does in stocks and art.

- Demand. There are internationally known artists whose works are available in galleries throughout the world. Others might not be offered everywhere. You want to

own the ones whose art is exposed to the most people, and the people who appreciate and can afford the art. Just as you are safer buying stocks that are sold in major market places and have some volume, you want art that meets that same criterion.

- Offered at auction. This sounds a bit redundant with several other criteria, but there is a subtle difference, and, as the French say, *viva la difference!* Auctions provide consistent, numerous, reputable opportunities to sell. Sellers know it. Buyers know it. Since the major auction houses, both domestic and international, are selective with who and what they offer, they bring credibility to the artist and the art. And they add to all of the above, i.e., track record, liquidity and demand.

In summary, you want to invest in the art that other people want. Art that others recognize as opportunities to buy for investment. There are artists whose works virtually never fall out of demand, from generation to generation. They represent a solid place to start. In virtually all other investment groups, individual items, whether they are stocks, bonds or parcels of real estate, fall out of favor from time to time. There are artists who never have.

To reduce the element of risk and speculation, in other words, one area of the art market stands out as the best place to invest.

You should collect art by the masters.

Unless you are prepared to spend millions of dollars on each piece you acquire, that means you should collect prints by the masters. Over the years, the "household names" in art have proven to be the safest, surest way to participate in the ever-

growing art market. They have demonstrated track record, liquidity and safety.

The safety aspect is enhanced by diversification. Since you can buy prints relatively inexpensively, you can own several by the same artists, and works by more than one artist. In addition to safety, diversification allows partial liquidation, if that is what you want to do.

Finally, collecting is fun! Buy what you love, hang it and appreciate it while it appreciates for you. That helps explain the success of artists who remain popular over the years. People enjoy their art. Beethoven's 5th symphony, written about two hundred years ago, remains one of the most played pieces of music on classical radio stations everywhere. People flock to Florence, Italy to gawk at Michelangelo's *David*, to Rome to see his *Pieta*, and record numbers of people visited museums the past few years.

Buying what you would enjoy living with takes the strain out of owning it, unlike other investments, and affords another opportunity. You can pass down the art from generation to generation. It could ultimately be sold or not, or donated to a museum or charity—at the prevailing value, of course!

Dos and Don'ts of Buying Art

1. Buy "name brands." Invest only in artists you and others have heard of—household names. This cannot be emphasized too much. It is the singularly safest, surest way to participate in the ever-growing art market.

2. Don't pay retail! This requires some bargaining acumen. It may be less important if you are satisfying an aesthetic or other appetite motivating you. But for investment, this is imperative.

3. Select an art dealer with care. Apply the same criteria you would in choosing a stockbroker, accountant, attorney, or doctor. Integrity and knowledge are foremost and inextricably intertwined. Either without the other is meaningless. Experience is next on my list. You know what else is important to you. It might be personality, meshing of mutual interests, whatever.

4. Buy what you love and enjoy it. This also cannot be stressed enough. Hold it a long time, if it is for investment, to maximize your return. Remember, art by the masters is limited. In an expanding global market, demand can only increase. You might as well enjoy it while you own it.

5. If it sounds too good to be true, it probably is. Remember the story of the BMW and the Kia. I would like to share some horror stories with you. Included in this book are Appendices of two columns I have written with specific tales of woe and caution. I strongly urge you to read them—and take them to heart. It could save you a lot of grief—and money.

At first glance, it appears that I am advising you not to buy art from art galleries, with my admonition about not paying retail. Not true. However, keep in mind that, with significant overhead, galleries need to get a larger markup than a private dealer, so negotiate hard on works by masters. Also, if a gallery has inventoried works of art, those are the pieces in which they are invested. They want to sell those pieces. As a former gallery owner and operator, I certainly preferred selling a Miro I had paid for and was hanging on my wall, than look for a different one or

a work by Chagall, for a client. In other words, you can probably do better buying from an agent than a principal.

There are many fine galleries throughout the United States, mainly in high traffic areas, who offer works by the masters. The mom & pop frame shop-galleries, if they have something, may not be aware of its provenance, history or true value. You might get a steal, but only if you know more than they do.

Always ask where they got the art. What catalog shows the particular piece? If it is an artist proof, how large is the edition? Is it supposed to be signed? When was it done? Did you know that every—I mean *every* original print by Renoir, Picasso, Chagall, Miro, and other 20th century masters are catalogued and generally provide the above information? That is also true for old masters, such as Rembrandt.

A final word of caution: don't let a salesperson tell you that the piece they have on the wall, say, number one out of a hundred [usually depicted as 1/100], is worth more money because it is a lower number. When etchings were created on copper, a soft metal, the lines could gradually flatten out and early pulls might be better. Not any more. And certainly not true of serigraphs or lithographs. The value is the same regardless of the number in the edition. By the way, there is always the possibility of a salesperson, faced with selling number 100/100 exclaiming: " This is the last one in the edition. When it goes, the work becomes a collector's item and could increase in value!" He may or may not be aware of a dozen other galleries, which have the same image with lower numbers, and simply have not yet sold them.

Summary

Unless you are an experienced and knowledgeable art buyer, know the real meaning of art terms. I have provided a glossary of

key terms you should know. Ask questions if you do not have access to catalogs and other references. Don't bid online on anything that costs more than you are willing to lose, unless you love it so much you don't care.

Like the stock market and the sea, a rising tide raises all ships in the world of art by the masters. Not unlike a good earnings report by IBM with positive forward looking earnings giving a boost to the entire technology industry. The 2004 sale of the Picasso painting of "Man with Pipe" fetched over $104 million, and will have a ripple down effect. Prints by Picasso and other twentieth century masters will appreciate. They always have.

Collecting prints by the Masters—especially 20th century masters--is the way to participate in the ever-growing art market. In the expanding global economy we live in, the timing has never been better.

HANDLING AND CARE OF ORIGINAL PRINTS

L ike any other valuable commodity, original prints should be handled with care. Antique cars are best garage kept. Antique furniture should be cared for to prevent drying out and cracking, or warping, for that matter, from humidity. Fine wine must be stored properly to prevent it from turning to vinegar. Valuable furs and clothing must be stored properly and cleaned only by experts.

And so it is with original prints. Works on paper, and that includes pastels, watercolors and drawings, as well as etchings, lithographs and other print mediums, have three natural enemies. They are acid, light and moisture. Care must be taken to guard them from those predators.

Proper framing can help you store, protect and display your art. Sure, you could keep each piece between two pieces of acid free paper or mat board and store it in a vault or storage facility which is temperature and humidity controlled. Museums do that. The threat from all the natural enemies—acid, light and moisture—is removed. I don't do that. I want to enjoy my art, walk by it, linger, discover something I hadn't seen before, and reflect on it a bit. I even move art around in my house, because there are rooms I don't go into very often. I'll bring a piece from one of those rooms into a high traffic area, and it is like discovering something new. Or renewing a relationship with an old friend. It is more important to me that art harmonizes with my soul, not my sofa.

You could store unframed pieces in your home, but, again, you don't get to see them. Bringing them out occasionally exposes them to the perils of handling: oil in your hands, spills,

drops, wrinkles and tears from mishandling. So for me, proper framing is a viable alternative.

First and foremost, the print must be matted. The mat separates it from the glass, so if there is a humidity problem in your home, moisture won't get trapped between the paper and the glass. Fine art is always printed on acid free paper, to prevent acid burn—browning—over time. So, second, the mat must be acid free. Cardboard, like newspaper, is highly acidic. That is why newspapers turn brown. Fish might be okay wrapped in newspaper. Art is not. Cardboard mats are unsatisfactory for fine art. Acid free board and wrapped fabrics, such as silk and linen, should be used. Third, the art must be hinged to the mat—not glued. Paper is organic. It breathes, absorbs and releases moisture, so it must not be constricted in any way. And the hinges and the paste must be acid free, as well. Masking tape, a staple of economy frame shops, is deadly.

Talk to your framer about your art and the procedures used in that shop to protect as well as beautify it. Make sure they understand acid-free framing, also known as "museum-style" framing and "conservation" framing. Ask if they have framed other valuable works of art in the past and if they have any examples of that work.

There is no proper way to frame art from a designer standpoint. Some people like contrasting mats. Others double, even triple mat, showing traces of color that bring out colors in the print. They use high gloss or metal frames on contemporary art. If that is what you like, go for it. Just remember, if someone comes into your house, looks at a $25,000 Picasso in a $500 frame and exclaims, "Great framing," you might have missed the point. I prefer more neutral matting and framing, like you see in museums, so the art is the star. Simple wood or hand carved frames with gold leaf can be beautiful with a hand-rolled Italian linen white or off white mat is elegant. That same Picasso will

leap from the paper! But that's my preference. There is no right or wrong.

We have not discussed light, the final enemy of paper art. Light is bad for a plethora of items. I didn't realize until I moved that a beautiful custom designed chair I had in my living room, with its back to a window, had completely faded. The paint on your car can fade in the sun. Do not hang valuable pieces where they will be exposed to direct sunlight. If your house is bathed in light, even indirect, consider the special glass available which blocks out much of the deadly ultraviolet rays from the sun. Museums use it and it may be worth the price difference. Twenty dollars or so to protect a prized possession worth thousands is cheap insurance. Ask your framer.

The issue of light is why museums have fewer exhibitions of art on paper, and, when they do, they run them for shorter time spans. It is not because they consider drawings and prints to inferior to paintings, as some believe. It is to protect their collection.

A sad but true story: I visited the Hermitage Museum in St. Petersburg, Russia in 1996. Its collection of art is staggering, in terms of quantity and quality. I was admiring a breathtaking, small painting of *The Madonna* by Leonardo de Vinci. It was luminescent, as though it were bathed in light. Then I realized it *was* bathed in light. There was no air-conditioning and the windows in that room were open, letting in fresh air and sunlight. I have often wondered if they added air-conditioning or fixed it, or if that tiny gem of creative genius has faded from the earth.

Don't let your valuable art fade from the earth. Properly framed and appropriately hung, it can last for hundreds of years. Just look at the pristine prints by Durer and Rembrandt that are still around. Most of them are three hundred fifty to four hundred years old.

Take care of your valuable art and generations of your family will enjoy it, if somebody doesn't opt to make a lot of money instead.

EPILOGUE

P atty's thirteen-year-old niece came to visit us in Malibu a few years ago. We were sitting in the living room and, out of the blue, Maddie said, "so tell me about the painting with all the people running through it." I laughed out loud, amazed and amused by her perception and imagination. It is a very abstract painting with no apparent images in it. No one had ever asked that question. I bought it untitled and named it *Racing Through Central Park*!

How I came to own the painting bears mention. About twenty years ago, a friend of mine told me about an artist he knew who lived in New York. Stan could not stop raving: "Check him out, Alan, he is an undiscovered master. He's never sold a piece of art, but his paintings are brilliant. Spectacular." He gave me the artist's phone number. I called Arthur Cauliffe that night.

Over the next month or so, Arthur and I spoke every week, and I agreed to visit him and see his art on my upcoming trip to New York for the annual ArtExpo. He gave me his address in Queens. During the taxi ride to his apartment, the neighborhoods kept getting worse. Even the driver looked uneasy. When we arrived at the building and I got out of the cab, a face resembling Vincent Van Gogh jutted out from a broken window on the fourth floor. At least half the windows of the five-story building were broken. The building was badly deteriorated.

"Klevit?" "Yes." "Stay there, I'll come down and get you." "That's okay, I can find my way up." "You stay put. I'll be right down. DON"T MOVE!" I stayed put.

Moments later, Arthur popped out the front door. "Follow me, and be careful where you step." I did and understood immediately why he had me wait for him. The lobby was a shambles, garbage strewn about, a rat scurried past my feet, and the stench of urine was disgusting. We took the stairs because the

elevator was not working. The stairwell was no better, but the worst was yet to come.

We reached his apartment. He had left the door open. "Just watch your step," he said as we entered. My heart sunk as I looked about. There was wall-to-wall newspaper on the floor. The only piece of furniture was a wooden folding chair set up in the living room facing a blank wall. A floodlight sat on the floor. A stack of canvasses leaned against the wall to my right.

Arthur pointed to the chair and I sat down. He explained that his electricity and water had been turned off, so he used a battery-operated floodlight to read. The newspaper on the floor was for him and his cat. It was then I noticed the kitty litter strewn about. The cat never appeared.

"You ready for the show, Klevit?" I nodded and settled into my chair. He turned on the floodlight, which lit up the wall I faced, and I noticed a single nail right in the middle of the light. Arthur lifted the first canvas from the stack, turned it around and hung it on the nail.

"Oh, my God!" My voice trembled. I was dazzled by the colors, overwhelmed by the charged energy that sprung from the wall. I stared for a few minutes, absorbing the passion and the beauty before my eyes. My pulse quickened. Then I nodded toward the next one. He smiled, removed the painting from the wall and hung number two. Another explosion of color and action and passion and excitement engulfed me. Images danced wildly on the surface, seemingly moving about with abandon. As they vanished, larger ones appeared. They too disappeared, replaced by still larger faces. Abstract expressionism bled with the violent strokes of Van Gogh into magical illusions.

So it continued, this parade of beauty and unbridled creativity. Twenty-two in all. Every one of them struck a chord within me and touched my soul. Neither of us spoke for over an hour while I sat spellbound, absorbing Arthur Cauliffe's world of

enchantment. He spoke first: "Whaddya think?" All I could do was nod. Finally, I wiped the tears from my eyes and told him I would like to exhibit his art in one of my galleries.

The rest of the particulars that day are not relevant. Suffice it to say, we settled on a date for a one-man show. Although he reluctantly admitted he was a great artist, he did not believe any of his paintings would sell. I guaranteed him at least one would. We laughed. We had a beer at a bar a few blocks from his apartment. He was banned from all the other bars in the neighborhood for getting drunk and fighting. We laughed about that, too. We went back to his place so I could get one more look. "Do they have names?" "No. You title them, Klevit. I just paint. This is about ten years of painting." I agreed. We shook hands and I left.

With its walls covered with Arthur Cauliffe masterpieces, each precisely lit, the gallery transcended to a higher level. It glowed. I could not remember it looking more beautiful. Not for the Chagall Show. Or the show of 20th century masters. Not for Miro or Rembrandt. Not even Picasso. Never. I had invited a few dozen of my best clients and they all showed up for the event.

They were spellbound. The accolades were effusive. Every piece was a hit, drawing admiration from this select group of astute art collectors. The obvious quality of the work, the talent of Arthur Cauliffe struck these owners of Picasso and Chagall, Matisse and Dali, Miro and Renoir. Each picked their favorites. I had written a biography for Arthur, describing how I saw his art, explaining how painterly he applied his strokes, the many layers of paint he used to achieve their beauty and transformational quality. I could not, of course, point to past success. Bottom line: nobody bought anything. I was crushed. Not for me. For Arthur Cauliffe.

I called him the next morning as promised. "Didn't sell anything, didya?" "Wrong," I retorted. "We sold one. The one I

named *Racing Through Central Park.* And the most knowledgeable art collector at the show bought it." That's how I came to own the painting which hangs in the most prominent place in my living room.

Flanked on either side by an original lithograph by Toulouse Lautrec and a gem by Picasso, diagonally facing works by Matisse and Miro, *Racing Through Central Park* more than holds its own. It is the star of the room.

For years I dreamed that they would find Arthur Cauliffe's body lying among the debris and litter in his living room, along with his twenty-one paintings. The paintings would find their way to the curator of the Museum of Modern Art in New York City and to the museum itself. Arthur would, posthumously, become a recognized master, like he deserved. I haven't had that dream in a long time.

For Arthur's sake, I hope his art is discovered, preferably before he dies. If not, I feel akin to Vincent Van Gogh's brother Theo. I will own the only work of art sold by a great painter who was not recognized as such in his lifetime. It doesn't matter to me. I wouldn't part with *Racing Through Central Park* at any price.

My art collection includes wonderful prints by twentieth century masters, all worth considerably more than I paid for them. Great investments, all! The rest of the collection, a greater portion, include paintings, sculptures, drawings, and prints by lesser known, even obscure, artists. But I love them and enjoy them as much as the pieces by the masters. None more than the masterpiece by Arthur Cauliffe.

There are many reasons to own art.

APPENDIX I

The Art Beat
By Alan Klevit

Lend Me A Hand

I thought I had seen the worst of it on the Internet. Chagall "lithographs" of dubious authenticity selling for thousands of dollars. Picasso "prints' [euphemism for offset reproductions] selling as originals. Works with stamped signatures selling as signed pieces. Outright fakes [pieces identified by artists as never having been done by them!] selling as the real thing. You find such travesties on the Internet, offered up by dealers and private parties who either don't know or don't care. Does it matter which it is?

I cannot caution you enough to know without reservation what you are buying or bidding on before you allow your finger to touch the **enter** key. I get questions from people who *"Ask the Expert"* about something they have bought and want me to validate their purchase. Alas. That rarely happens.

I am sad and frightened to report that things have gone from bad to worse. I was surfing TV channels a few nights ago, when I was stopped in my tracks at Channel 345, "Fine Arts Auction." A familiar Picasso image, *"Women of Avignon,"* filled half the screen, a lovely young lady, hands pointing toward it, standing at its side. A man's voice was drawling about this "gen-u-wine gee-clay by Peecaso," the Vanna White wannabe nodding her head. "It's numbered, too," the voice continued in a folksy style, "and it has been signed by the Peecaso Domain." A billboard insert identified the piece as such and listed its appraised value at

$7,000. The bidding started at a hundred dollars, and, with constant urging from the mysterious voice and nodding of approval and pointing by Barbie, the final bid was nearly two thousand dollars.

The bad news:

1. The Picasso Family authorized certain images painted by Picasso to be produced in limited print editions. Not giclees. They bear the signature of a member of the family. They have never implied that the pieces were original. Depending on framing, time and place, those pieces generally sell between $750 and $1,100.

2. A giclee is a reproduction generated by a computer from a photograph downloaded into the computer. It can be quite colorful and realistic, even gaudy, with lots of ink splashed on the surface, which could be paper or canvas. It could look like an original painting on canvas. But it isn't. It isn't an original anything. It can be produced in unlimited quantities, and its value should be no more than a hundred bucks, plus something for the frame.

There is no good news. I could not figure out the medium or process used to create the next offering, despite thirty years as an art dealer, gallery owner and art publisher. Nor had I heard of the "Outstanding World Renowned Contemporary Master" whom the voiceover said painted it. It, too, had a $7,000 appraisal and the approval of The Girl in the Golden Gown.

I couldn't bear to watch and listen to another person possibly get ripped off. So I switched channels. I felt my heart bounce off the pit of my stomach. The very next one was "Fine Arts Treasures." I cannot report on what they were selling, because I turned off my set. I am afraid that, with hundreds of channels

available out there, the proliferation of places offering dubious art at seemingly made-up prices to unsuspecting, naive viewers is in its infancy, with perhaps the potential to exceed that on the Internet.

I know, some say you can't cheat an honest man. Everyone is looking for a deal. And just maybe if you pay $1,000 for something you think is worth $7,000, you are either greedy, stupid or both. If someone offered me a BMW for less than the cost of a VW, I'd want to look under the hood and test drive it, no matter what the hood ornament was.

Still, just because there are unsuspecting people who can be fooled and mislead, and, ultimately, cheated, does that mean it's okay to do it? Not in my neighborhood. And I would bet, not it yours, either. Unfortunately, I suspect that far more people see those channels, hear that drivel and succumb to that con than read my column. So help me spread the word.

APPENDIX II

The Art Beat
By Alan Klevit

Don't Buy Art at a Yard Sale

People like to brag about the piece of art they bought at a fraction of its value. Maybe they spied it lying on the ground at a yard sale. Everybody likes a bargain. Including me. If you can get me a BMW for the price of a KIA, I'll be at your house in twenty minutes. Of course, I will insist that you allow me to lift up the hood with the BMW emblem on it, and check out the engine. You also couldn't blame me if I wanted to start it up and drive it, to see if it accelerates and corners like a BMW or a KIA.

The home of the New Millennium Yard Sale may well be eBay, the cyber-garage store of the Internet, the new haven for bargains, and I don't mean that wonderful town in Connecticut. I am not here to impugn eBay. They are not doing anything legally wrong. Morally might be another issue, since they accept no responsibility for anything sold through them. But PLEASE! Be careful what original art you "steal" on line. After spending the past hour scrolling through the art works being auctioned on eBay, I am compelled to warn you. I found many of the listed items misleading, if not downright misrepresentations of what they were or were supposed to be.

A signed Picasso linocut for $160? I don't think so. First of all, there are no original linocuts by Picasso as small as 8X10 inches. Second, his linocuts sell in the thousands of dollars, often over $50,000. An "original" lithograph from the Vollard Suite for $95? No such animal. The Vollard Suite consists of one hundred

etchings. The lithographs are reproductions of those etchings, hardly original. Not unlike photocopies on really good paper, and beautifully packaged and boxed. That doesn't mean you shouldn't buy one if you like it. Just don't pay five times what it's worth, because you think it is something it isn't. And there was that signed and numbered lithograph by Marc Chagall. Except that it was not an original lithograph and Chagall had nothing to do with it. Years after his death, some people reproduced a limited number of copies of several Chagall paintings. These are offset lithographs, reproductions, like the cover of TIME Magazine, photo-mechanically reproduced, not original anything. The seller revealed that the signature was a facsimile. That means a stamp was made of Chagall's signature and applied to the reproduction.

Etchings by Rembrandt turned out to not to be by Rembrandt. Ditto for etchings by Renoir. I found that works attributed to the Masters were often mislabeled, descriptions of them misleading, and references about them specious. It is especially offensive when the offerings are by art dealers who you think would know better. Makes one wonder if they really are art dealers.

Some people I have known in the art world for years are selling online, and they honestly describe exactly what they are— and are not—offering. Unfortunately, [1] you might not know who they are, and [2] you might not know who they are not. So bidding online for novices is challenging work.

Not all the works by the Masters were misrepresented. Amongst the rubble were some gems: an aquatint by Picasso from the 347 series catalogued and correctly described; an authentic Picasso ceramic plate, also accurately described and referenced to the appropriate catalog. With my nearly thirty years experience in the art world, specializing in the 20th century

Masters, I can cull the good from the bad and the ugly. I suspect that the average person has no idea what they are buying online.

Unless you are an experienced art buyer and know the real meanings of such terms as lithograph, etching, signed and numbered, original, print, et al, don't bid on anything that costs more than you are willing to lose. Remember, if something appears too good to be true, it probably is. Tell the truth. If you were driving by a yard sale where a family was moving and getting rid of stuff it no longer needed or wanted, and you saw this piece of art in a nice frame, and you could read the signature, *"Picasso,"* and the man told you that it's been in the family for years, and he wanted ten dollars for it, even though he "knew" it was an original signed Picasso, would you believe him?

Happy hunting.

GLOSSARY OF TERMS

ABSTRACT EXPRESSIONISM American art movement begun in the 1940s and using expressive & spontaneous methods of applying paint, usually with abstract imagery. Rothko, Francis and Pollock are examples.

AQUATINT Etching process that creates tones and shades resembling watercolors.

ART COLLECTOR Any person who buys original art for pleasure or investment.

ARTIST PROOF Originally intended as an example of a "work in progress;" that is somewhat archaic; now a mini-edition, usually an additional 10 percent of a larger print edition, usually identified as AP, EA or PA.

CARBORUNDUM Etching that incorporates silicon carbide [carborundum] in the process, resulting in examples that have depth and texture otherwise not attainable.

CHIAROSCURO The contrasting effects of light and shade, employed by Leonardo de Vinci and Rembrandt.

CUBISM Invented by Picasso & Braque in the early 1900s, it depicts real objects flattened out to show all sides simultaneously in 2-dimensional format, showing the relationship between form and space, changing the course of Western art forever.

D'APRES Literally means "after" in French, d'apres refers to prints created based on works of art that already exist.

DRYPOINT Original print created by incisive drawing directly into a plate, without the use of acid baths.

EDITION Number of examples created of the same original print.

ETCHING Original print created by the process of an artist drawing into a wax ground applied over a metal plate, which is then submerged in a series of acid baths, then inked.

FAUVIST From the French for "wild beast," this early 20th century style is characterized by strong colors and expressive brushwork, which convey an emotional and fantastical depth. Matisse was the leader.

GICLEE Reproductions created by using the ink-jet process, usually with many colors and high resolution.

HORS COMMERCE Prints not for trade, often special payments, generally identified by the notation "HC."

IRIS PRINT Specific giclee created on the Iris Four Model of the Scitex Corp.

LA BELLE EPOQUE The "Beautiful Era" in France's history, that began in the late 19th century and lasted until World War I. Considered a golden time of beauty and culture, it encompassed impressionism and art nouveau, the latter including such artists as Cheret, Mucha and Lautrec.

LINOCUT Original print created by carving or gouging an image into a linoleum block, then inking the block and pulling the impression. Also known as linoleum block.

LITHOGRAPH Original print created from images drawn directly on stones or plates, which are separately inked and pulled, based on the concept that oil and water don't mix.

MAQUETTE A model—usually small--of an intended work, such as a sculpture or piece of architecture.

MEZZOTINT Original print utilizing specific etching process of scraping and burnishing the plate thereby created special effects in texture and shading.

MONOPRINT Original print created by any or a combination of printmaking techniques, which is then hand-finished or colored.

OEUVRE The body of work of an artist.

OFFSET LITHOGRAPH Reproduction created by offset lithography, utilizing the four-color separation process [use of 4 negatives]. The cover of Time Magazine is an offset lithograph.

ORIGINAL ART A work that that is the direct result of a creative idea or concept, such as a painting, sculpture, drawing, ceramic, or print.

PLATE SIGNED Print in which the artist signs into the stone or plate, which makes his signature part of the image of the print. Not to be confused with a stamped signature or a reproduction of a painting which was signed and the signature appears in the reproduction.

POP ART A movement of the 1950s inspired by a consumer society and advertising. Warhol [and his soup cans] is the quintessential example.

PRINT Original work of art created from a range of techniques or mediums, such as etching, lithography, and serigraphy.

REPRODUCTION A copy of an original work of art that can be produced by a myriad of processes, including offset lithography, giclee, photocopy, and facsimile.

SERIGRAPH Original print created from images are drawn on silk mesh stencils by the artist, through which ink is pressed onto open areas on the paper.

SIGNED & NO. Generally denotes that the piece has been numbered to reflect the size of the edition and which print this piece is in the series [e.g. 32/75]; then hand-signed by the artist, attesting to its authenticity and quality.

SURREALISM Developed from Dadaism in 1924, this school represents reality through dreams and pure thought inspired by the writing of Freud. DeChirico, Dali & Miro were early practitioners.

WOODCUT Same as linocut except that a wood block or series of blocks are used to create the original print. Also know as wood block or wood engraving.

SUGGESTED READING

Over the past thirty-plus years immersed in the art world, I have read too many books to suggest a bibliography. My current library includes several hundred books devoted to the arts, and is constantly growing. I have over a dozen books devoted exclusively to Picasso, including half a dozen Catalog Raisonees, and just as many catalogs on Chagall. I have subscribed to *Art News, Art in America,* periodic catalogs by major auction houses, and *Art Price.com.* I have visited museums and galleries all over the world and met with famous and unknown artists. Art education is an ongoing process.

I recommend the following books as a starter set for those of you interested in pursuing your art collecting education:

THE ART OF THE PRINT by Fritz Eichenberg [1976]. You'll need to get it second-hand but it is the "bible" on printmaking by the former curator of the Cincinnati Art Museum.

THE SKETCHBOOKS OF PICASSO ed. by Arnold and Marc Glimcher [1986].

THE COMPLETE WORKS OF REMBRANDT ed. by Gary Schwartz [1977]. In addition to containing all 399 etchings by Rembrandt in their original size, there is a wonderful description of the etching process in the front of the book.

To keep current you might also subscribe to either *Art News* or *Art in America*, monthly magazines, and consider receiving complimentary copies of my column, *The Art Beat*, if your local paper doesn't carry it. Let me know at alan@the-art-beat.com.

And visit museums and galleries. Do all this and you will be ready for *Art Collecting 202!*

Other books by Alan Klevit

Three Days in Sedona
The Art Beat

Printed in the United States
104429LV00001B/57/A